Emma Farrarons is a French illustrator and
graphic designer. Born on the island of Cebu in the Philippines,
Emma grew up in Paris.

She was trained in illustration at the Edinburgh
College of Art and l'École nationale supérieure des Arts
Décoratifs. Having completed a textile and printmaking course at
Capellagården school in Sweden, she has developed a particular
love for pattern and fabric print and is inspired by French,
Scandinavian and Japanese design. She illustrates and
designs books, posters and stationery.

When she is not drawing and designing, Emma
enjoys cookery, sewing, travel and practising mindfulness.
She lives in London with her Danish husband.

Also by Emma Farrarons

A to Z of Style by Amy de la Haye,
illustrated by Emma Farrarons

London Colouring Book by Struan Reid,
illustrated by Emma Farrarons

The MINDFULNESS COLOURING BOOK

Anti-stress art therapy for busy people

Emma Farrarons

BOXTREE

First published 2015 by Boxtree
an imprint of Pan Macmillan, a division of Macmillan Publishers Limited
Pan Macmillan, 20 New Wharf Road, London N1 9RR
Basingstoke and Oxford
Associated companies throughout the world
www.panmacmillan.com

ISBN 978-0-7522-6562-9

Visit **www.panmacmillan.com** to read more about all our books
and to buy them. You will also find features, author interviews and
news of any author events, and you can sign up for e-newsletters
so that you're always first to hear about our new releases.

For Asger Bruun Jakobsen

INTRODUCTION

We all lead busy lives, rushing around on autopilot, charging from place to place, multi-tasking at work, taking care of our families and trying to stay in touch with friends. But we now know that taking a moment to pause and be mindful can dramatically improve our well-being, making us feel calmer, less stressed and more at peace with our emotions.

Being mindful is about paying attention to the present moment, clearing your mind of distractions and focusing on simply being. Pretty much any activity, done right, can be an exercise in mindfulness – walking down the street, eating a piece of chocolate or simply breathing in and out. But the act of colouring in – carefully and attentively filling a page with colour, the feel of the pencil in your hand as you meditate on the beauty of the whole illustration – is particularly suited to mindful meditation.

The exquisite scenes and intricate, sophisticated patterns in this little colouring book offer a perfect calming exercise in mindfulness and creativity. Whatever you are doing, wherever you are, we hope you will enjoy these beautiful drawings . . . colour in, de-stress and be mindful.

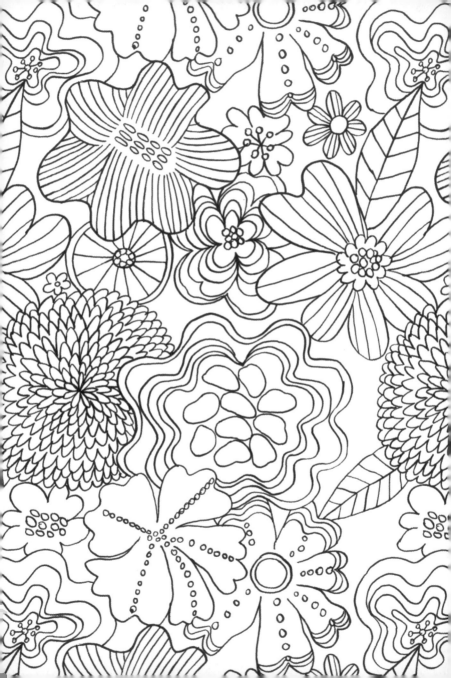

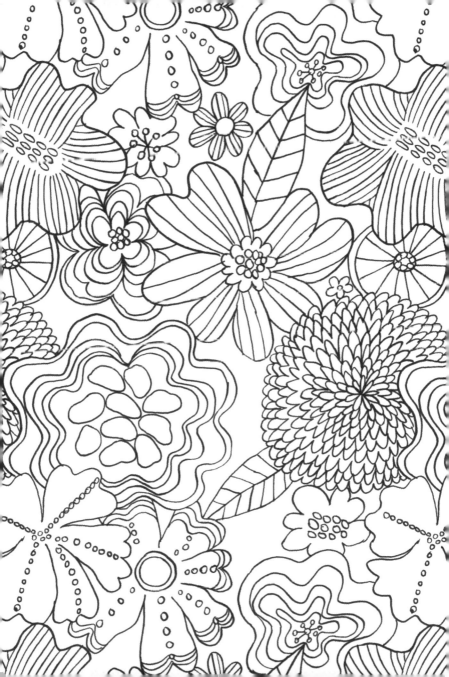

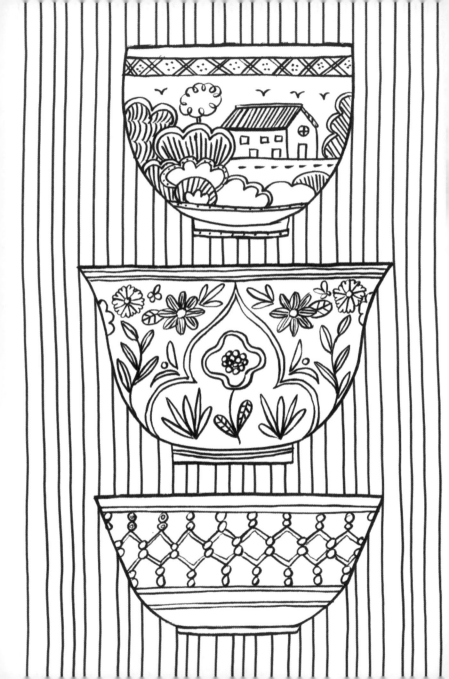

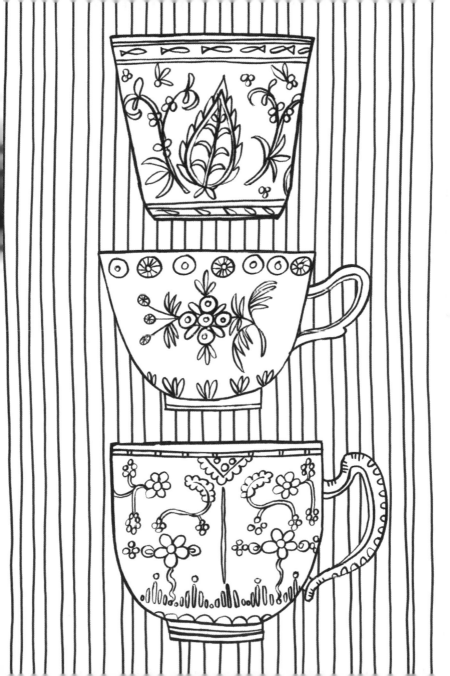

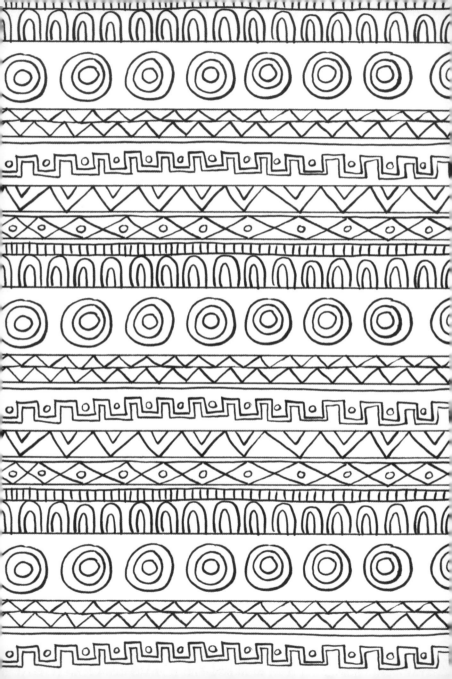

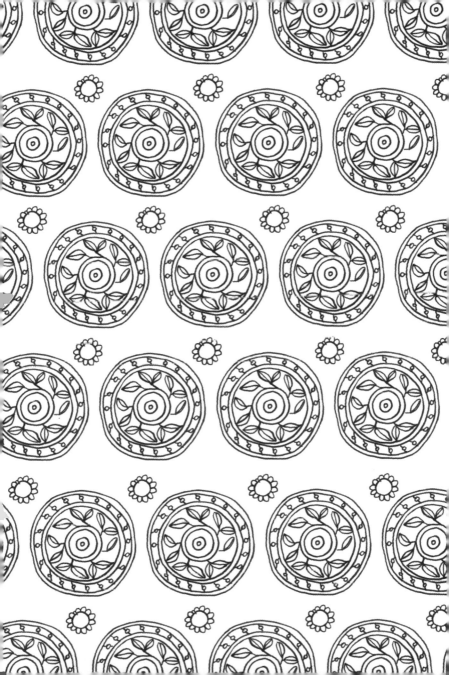

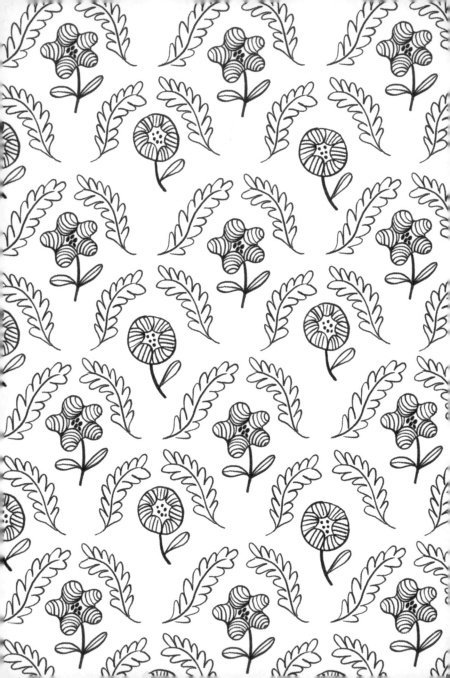

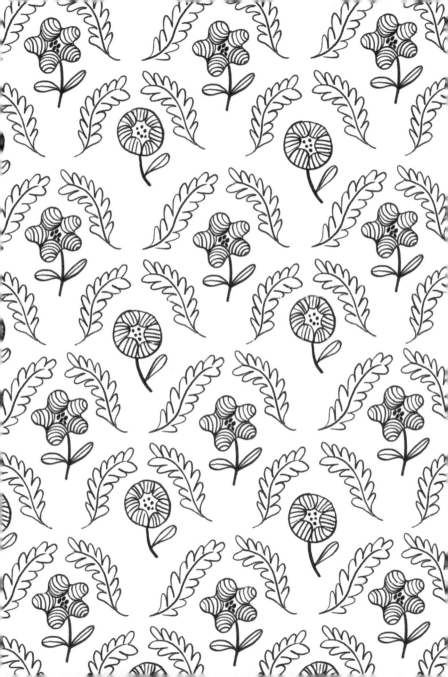

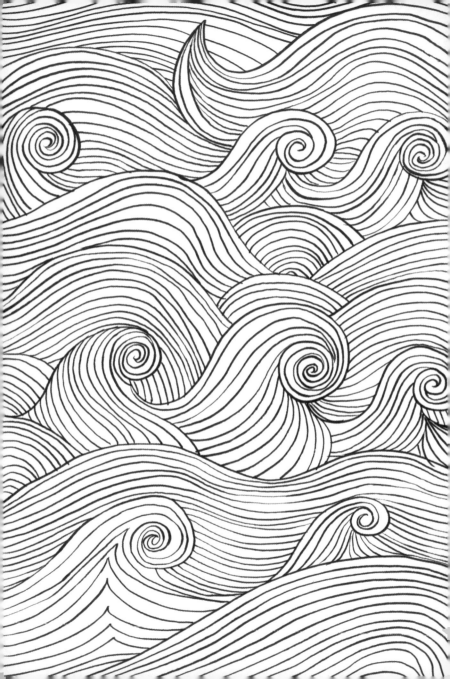

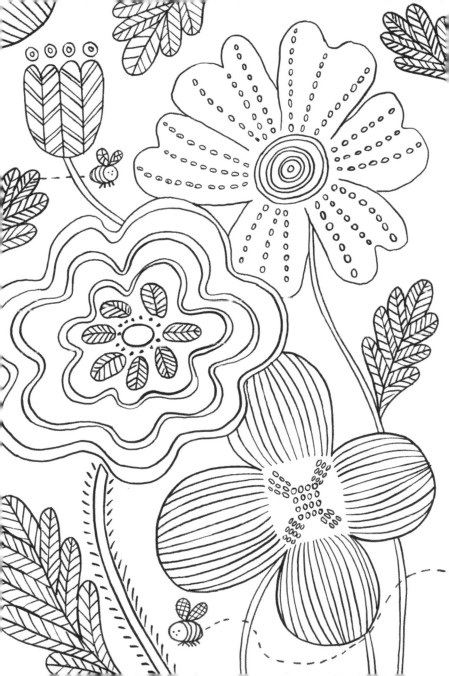

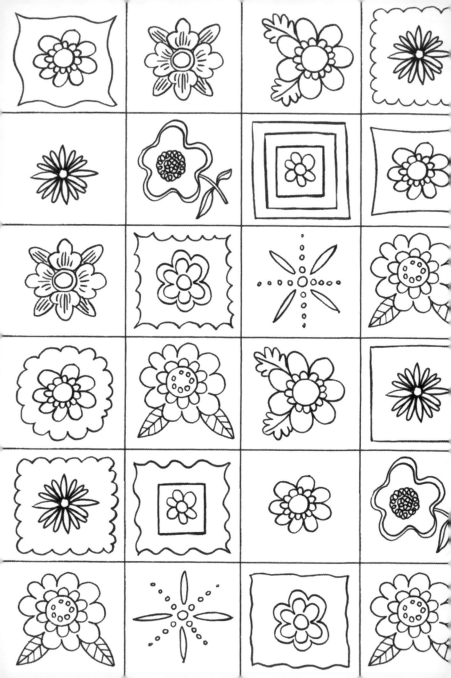

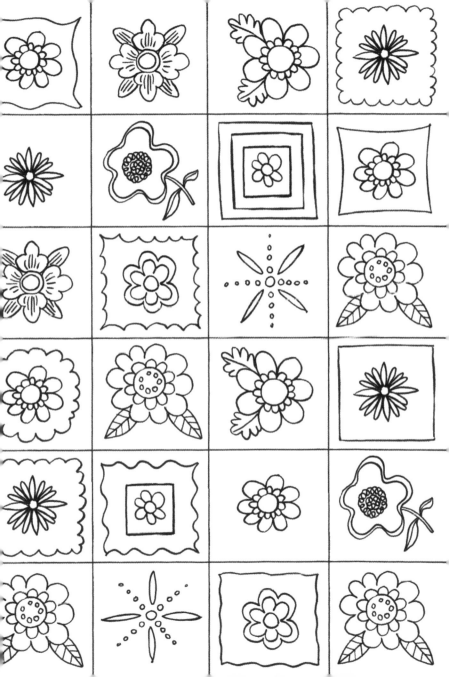

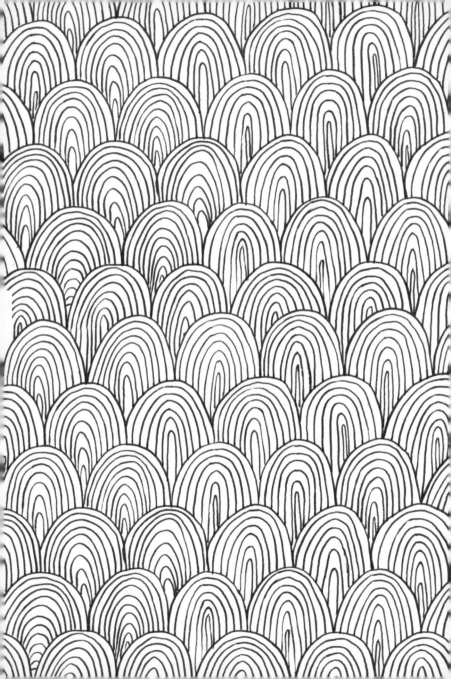

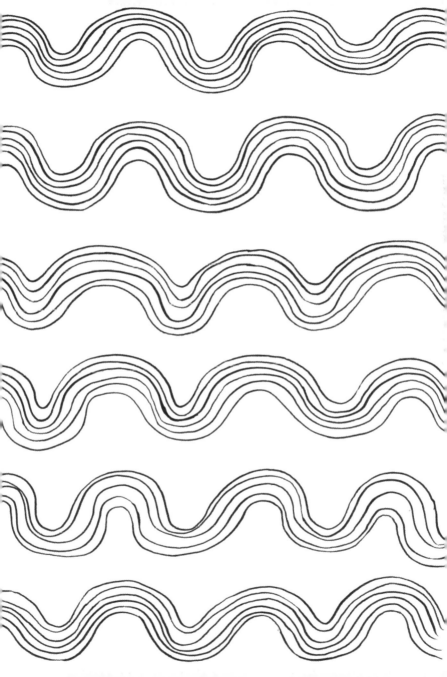

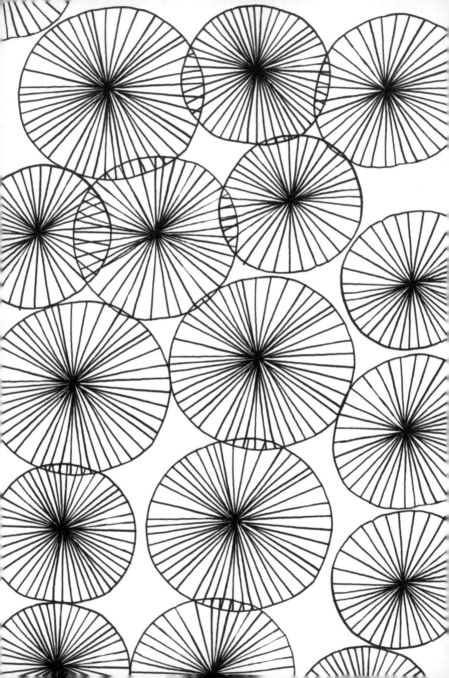

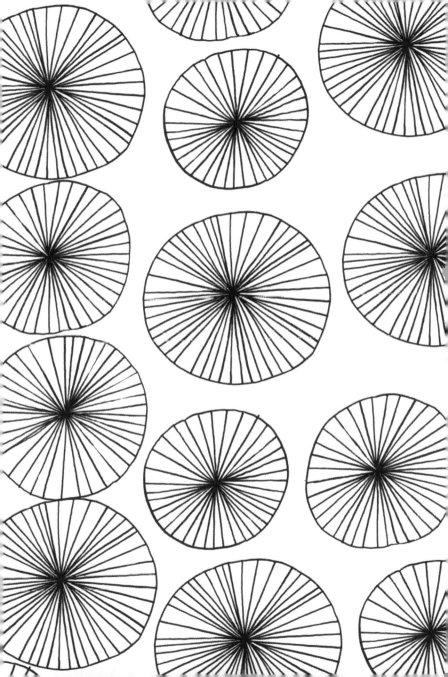

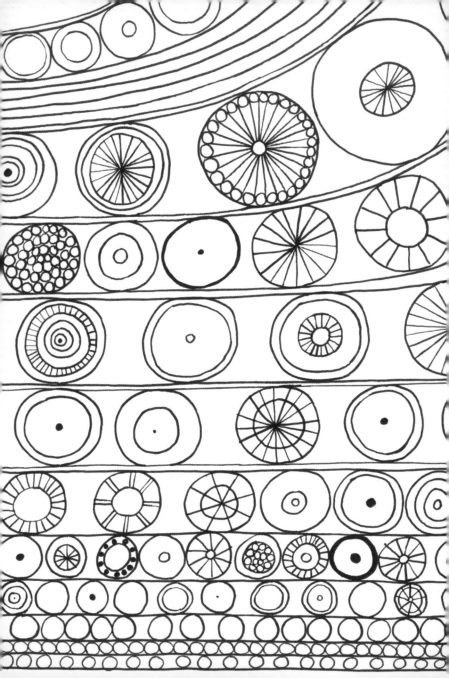

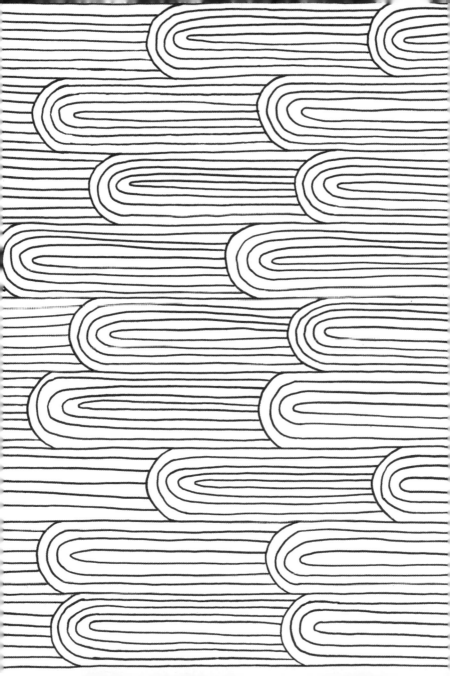

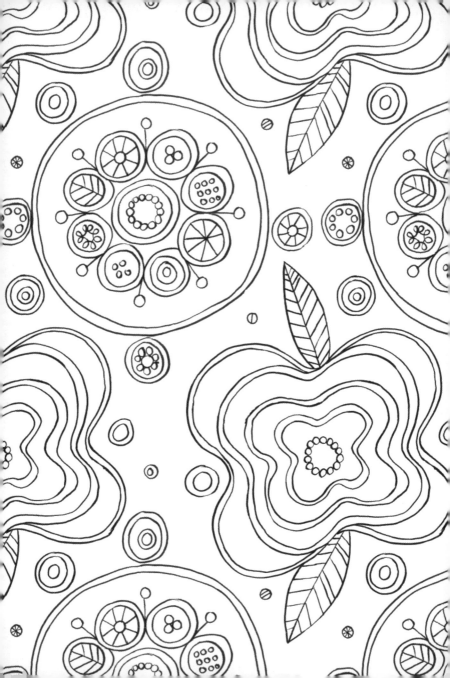

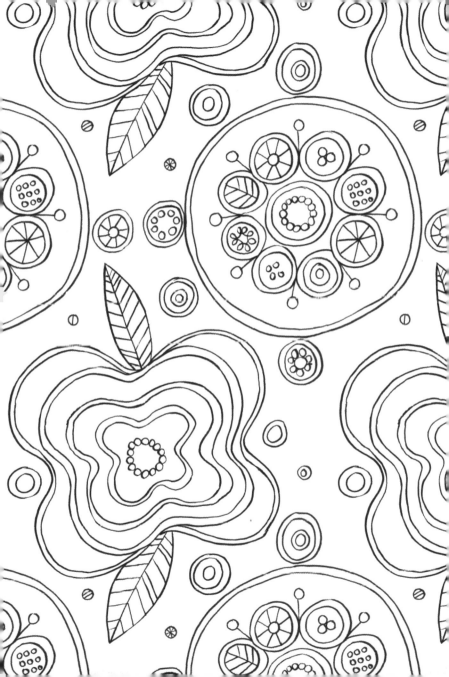

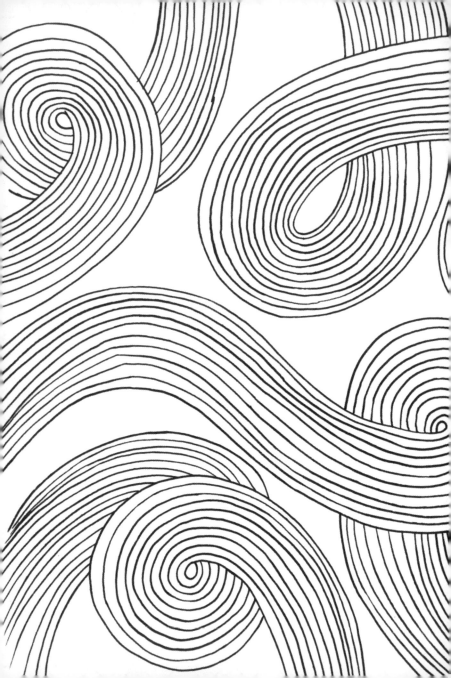

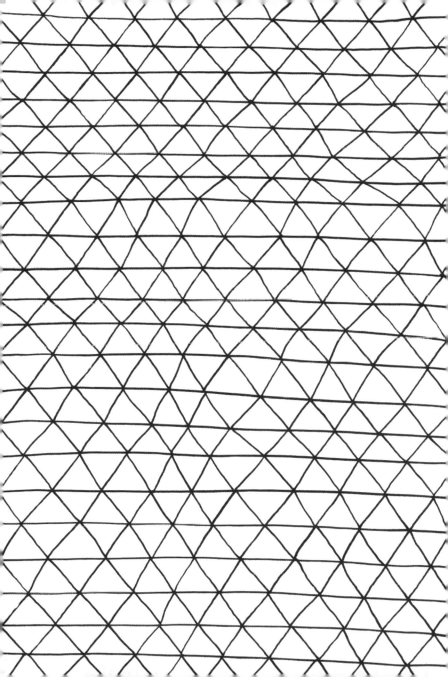

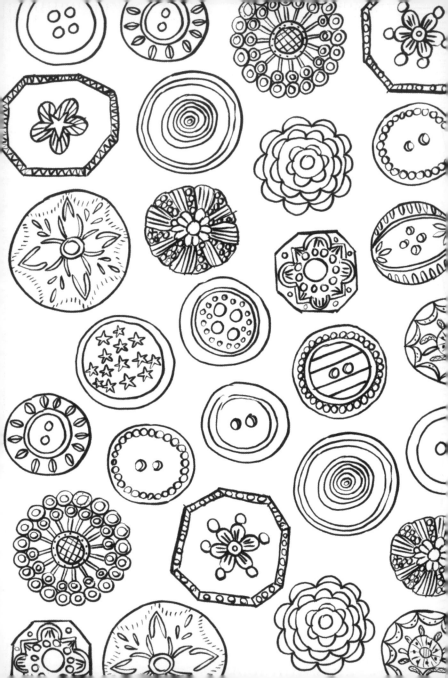

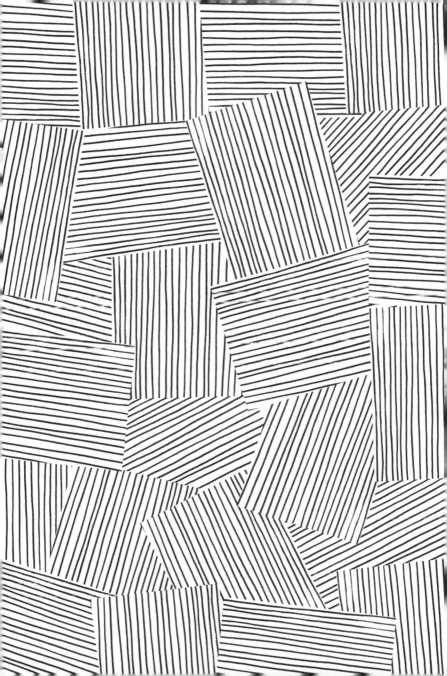

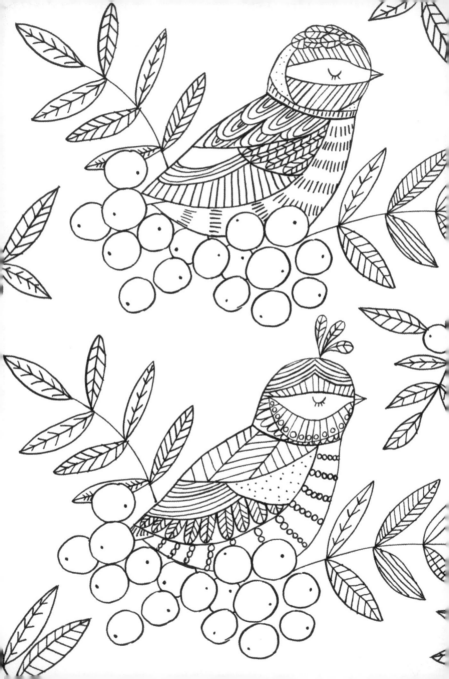

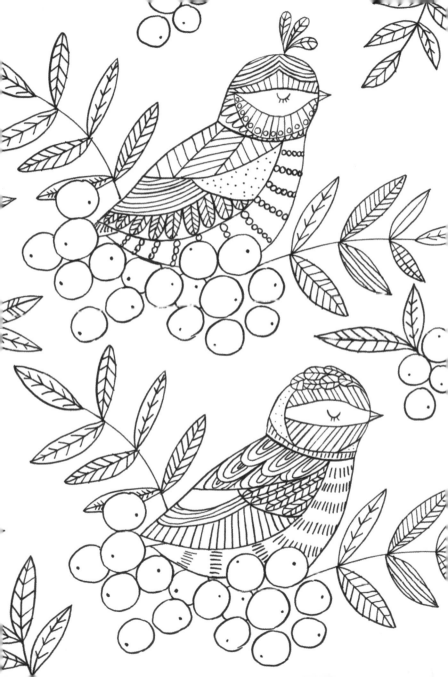

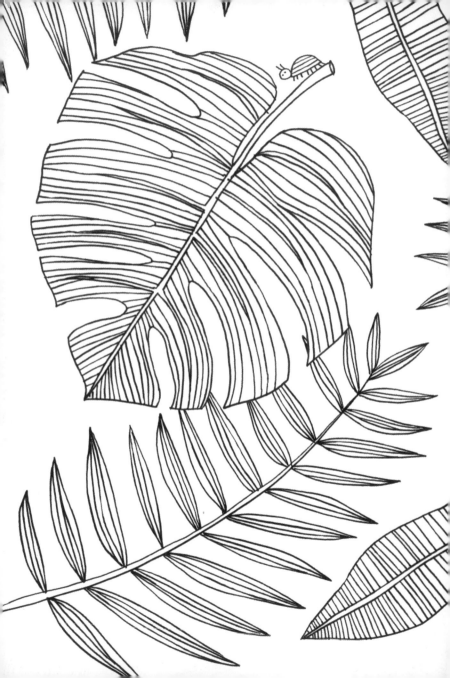

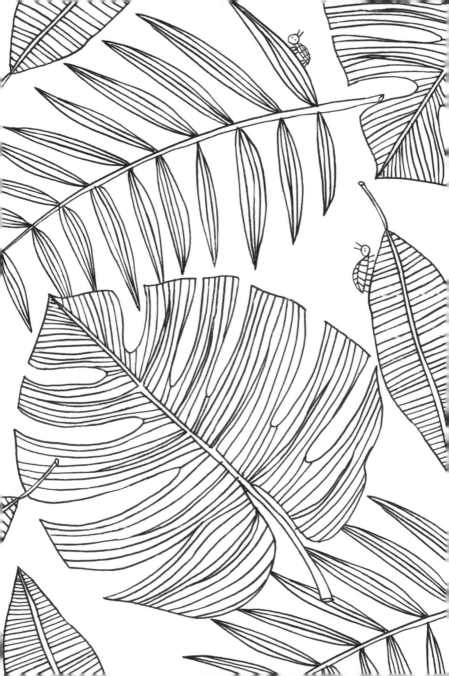

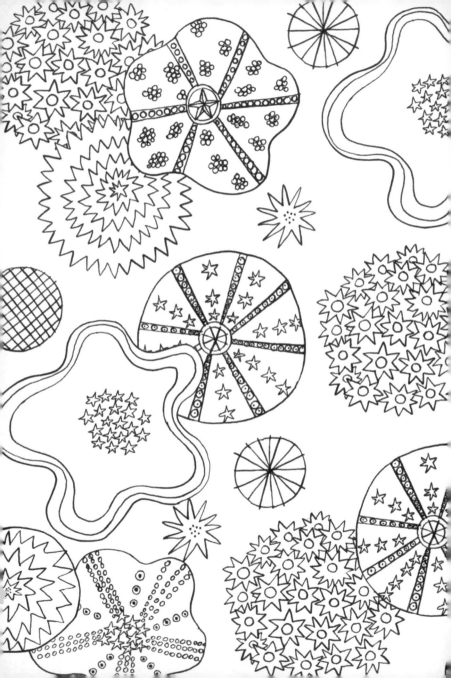

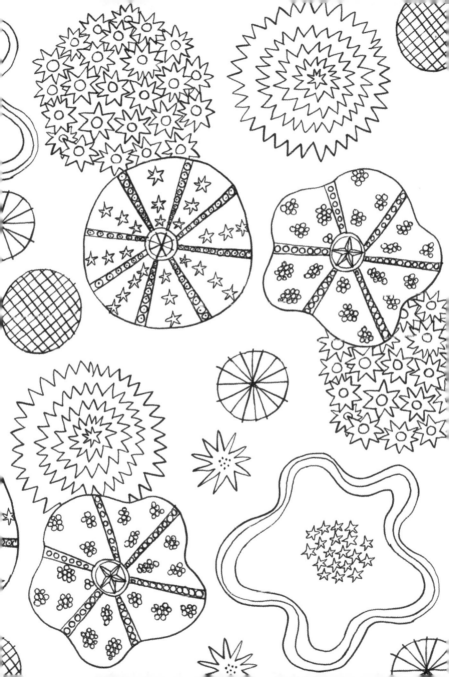

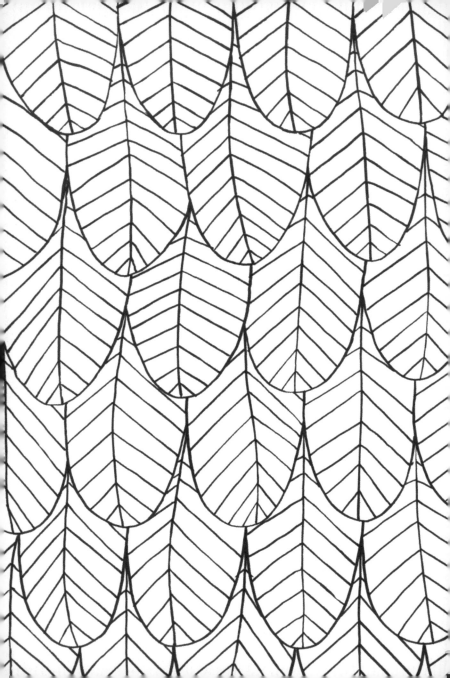

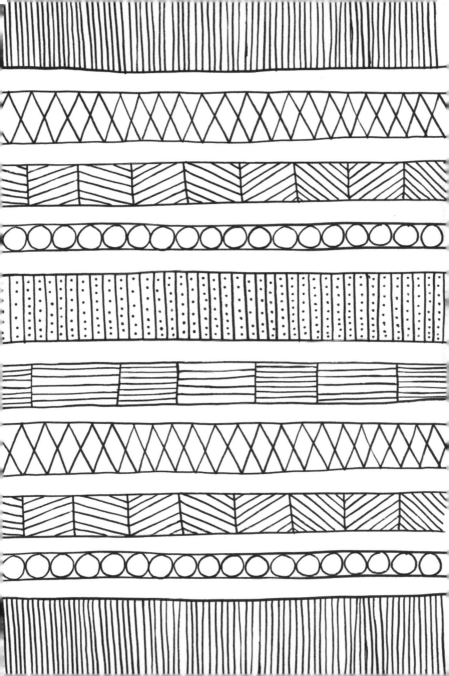

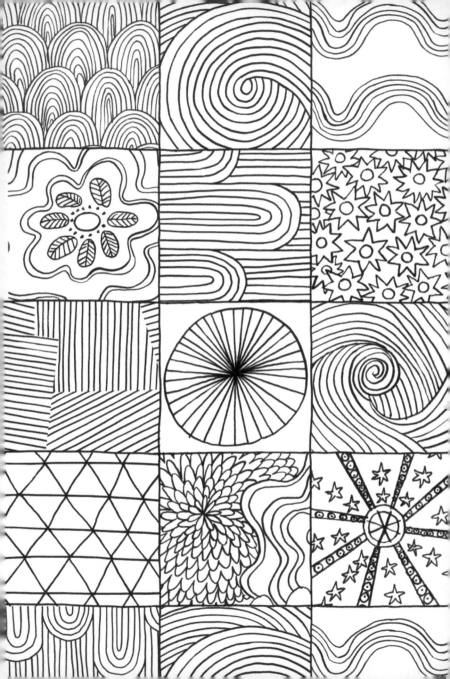

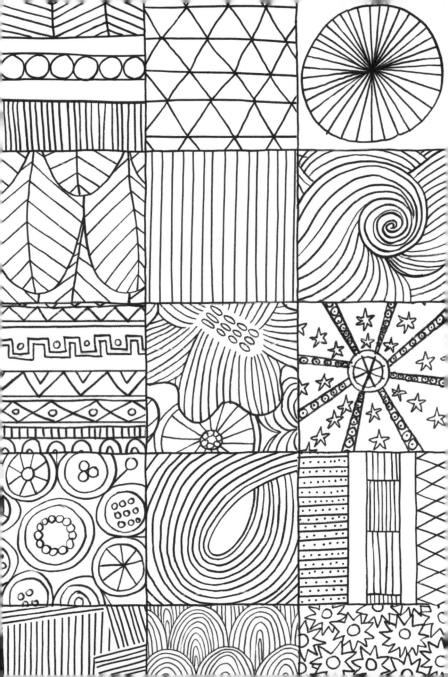

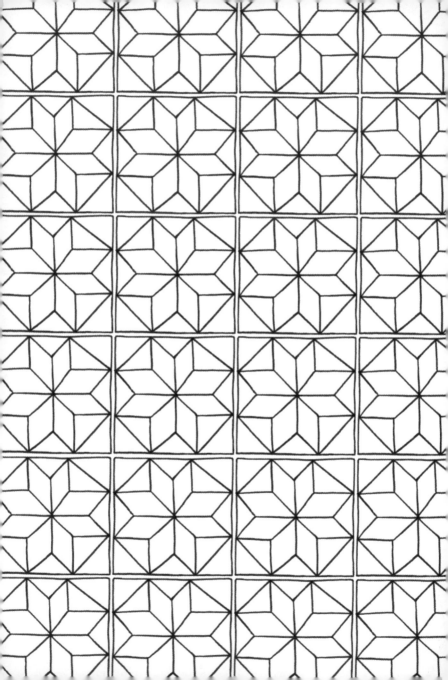

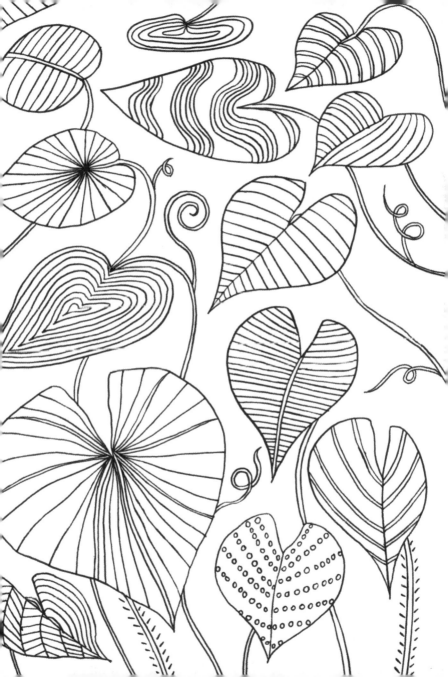

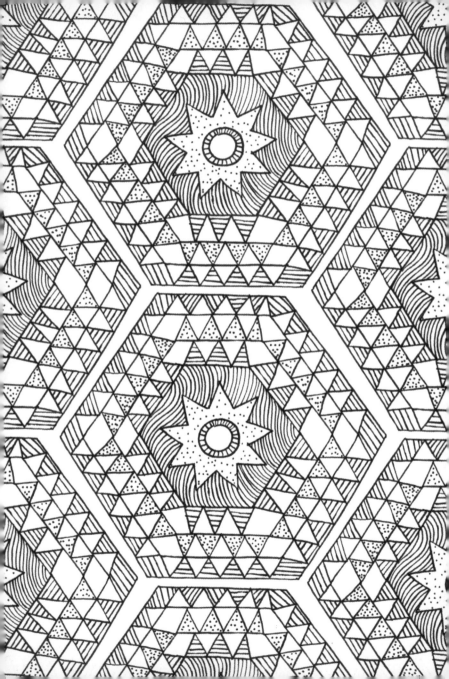

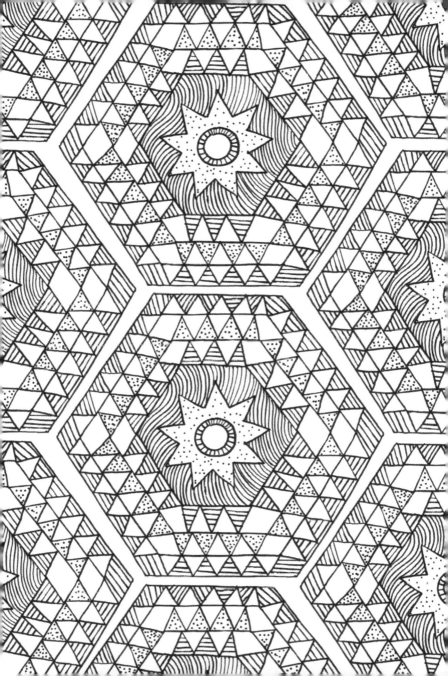

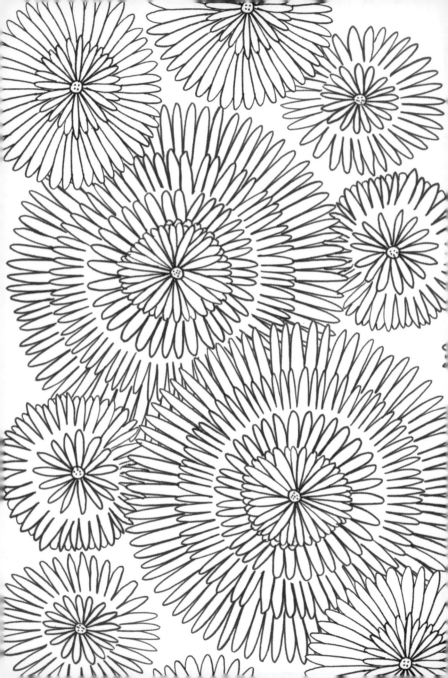

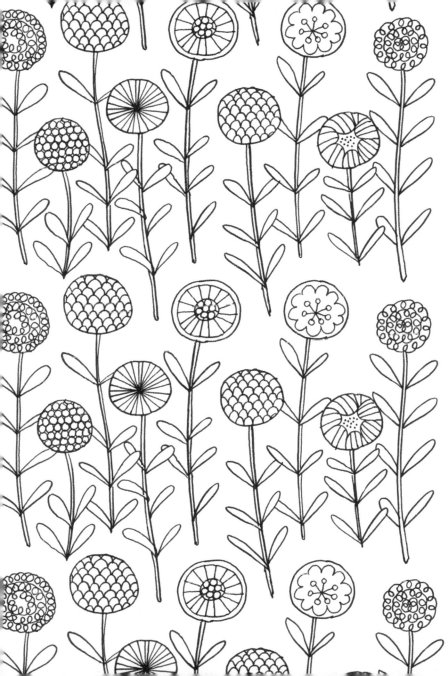

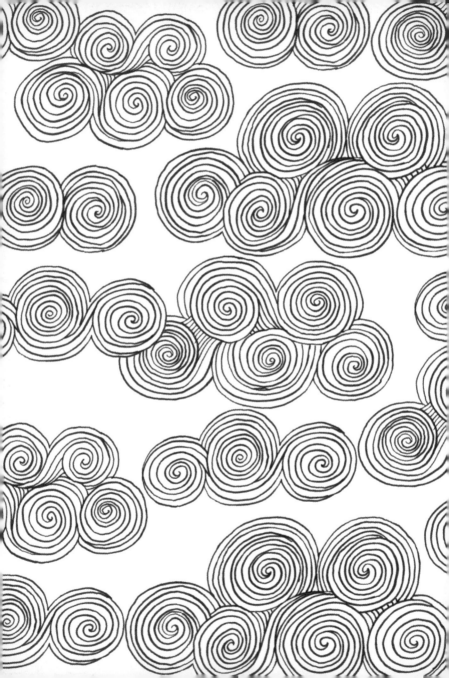

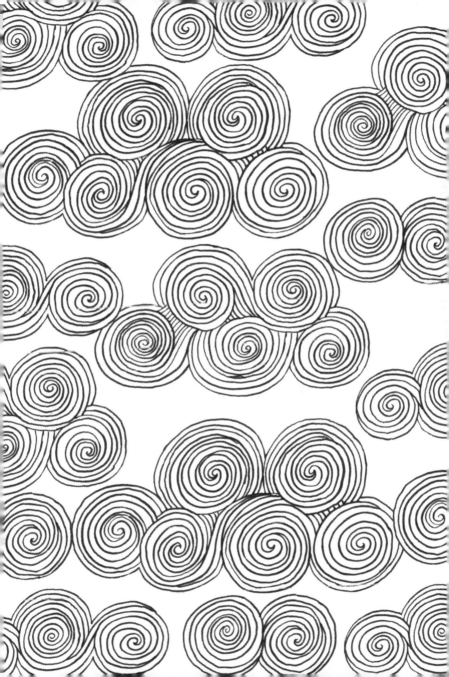

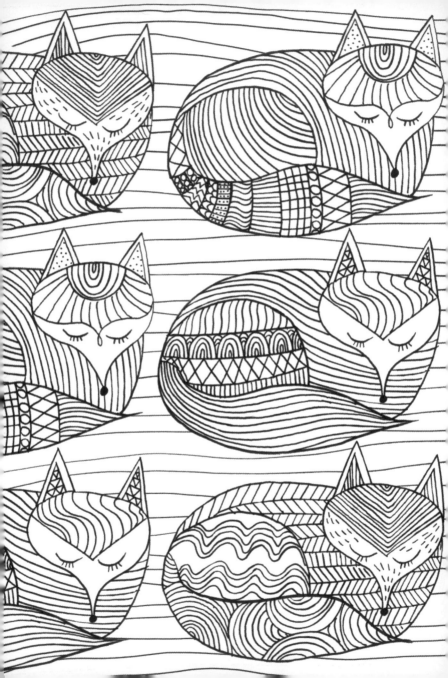

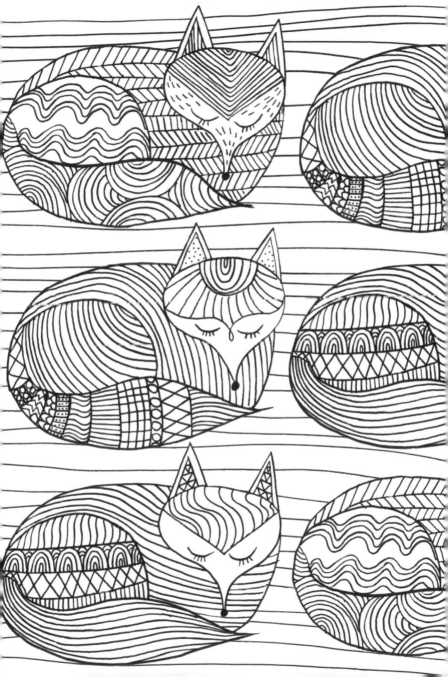

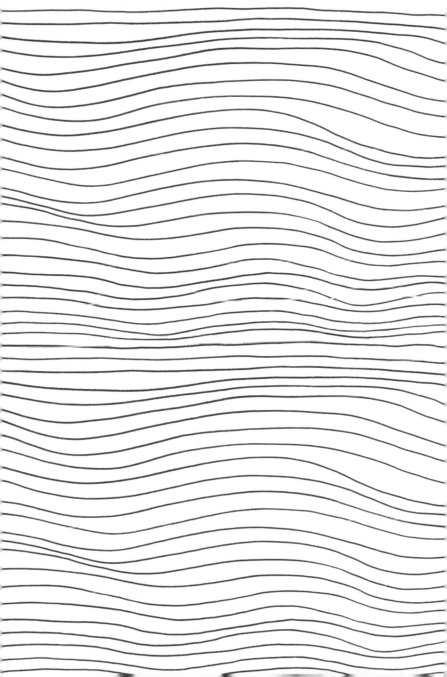

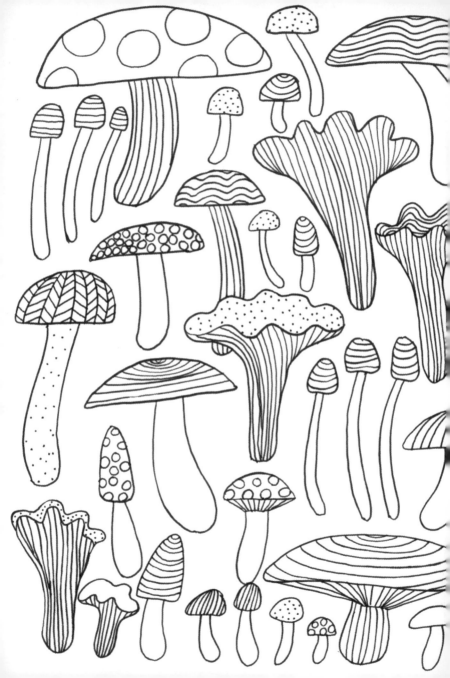

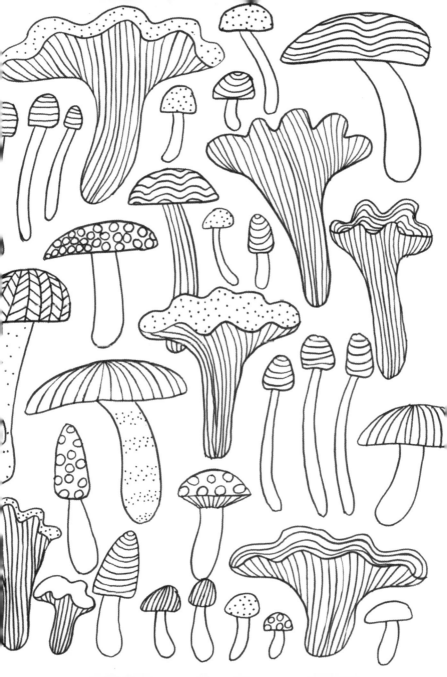

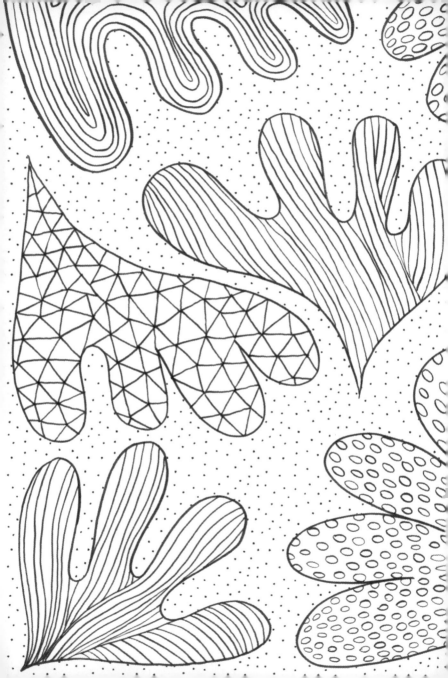

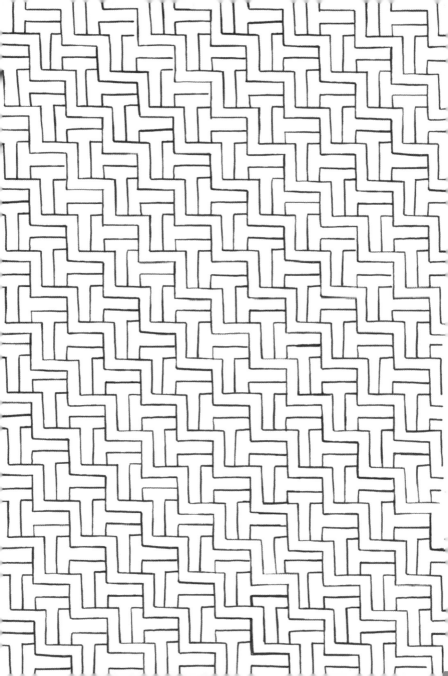

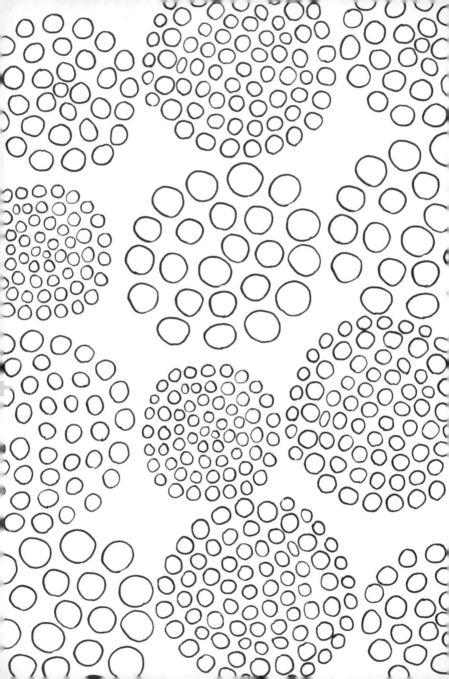

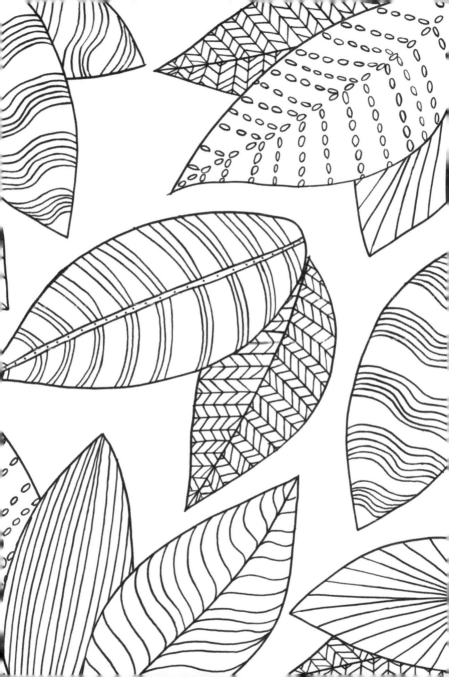

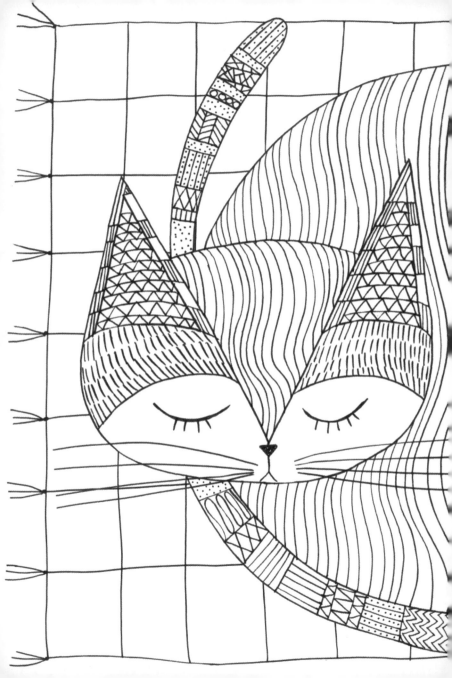

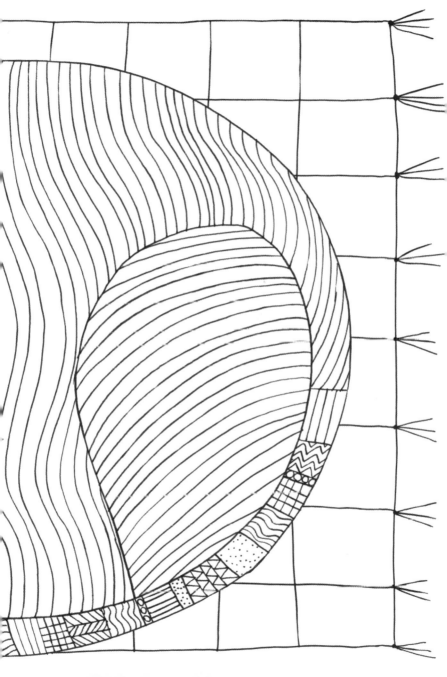

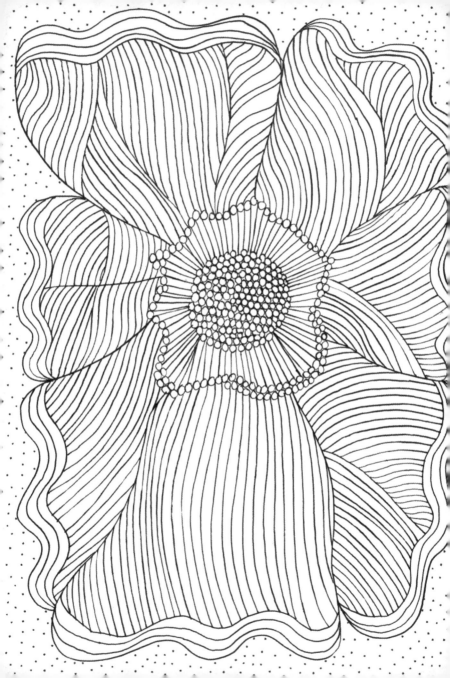

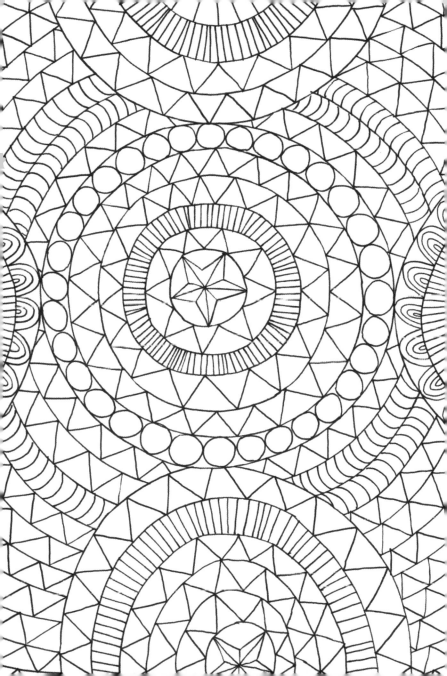

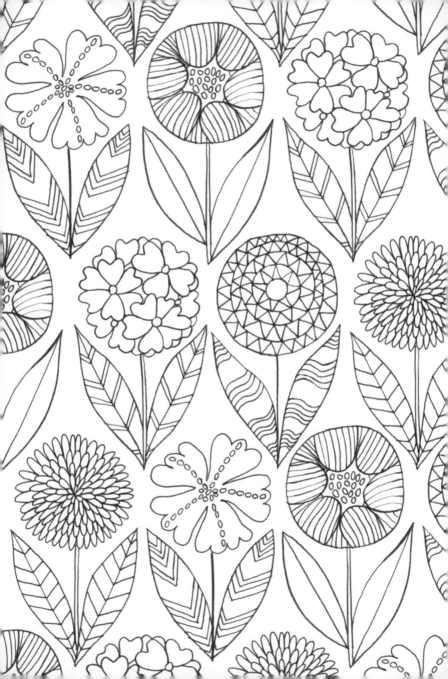

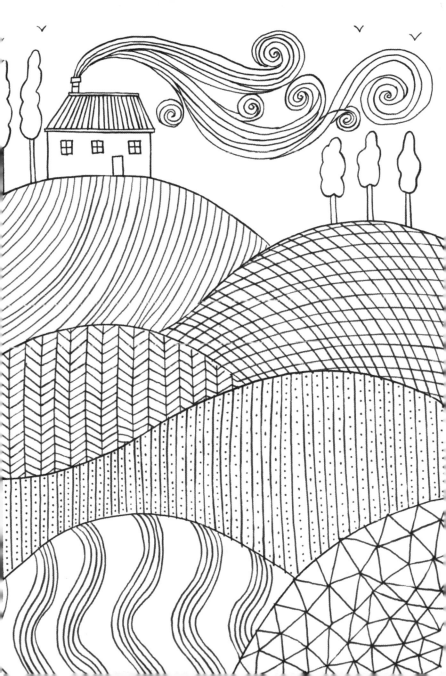

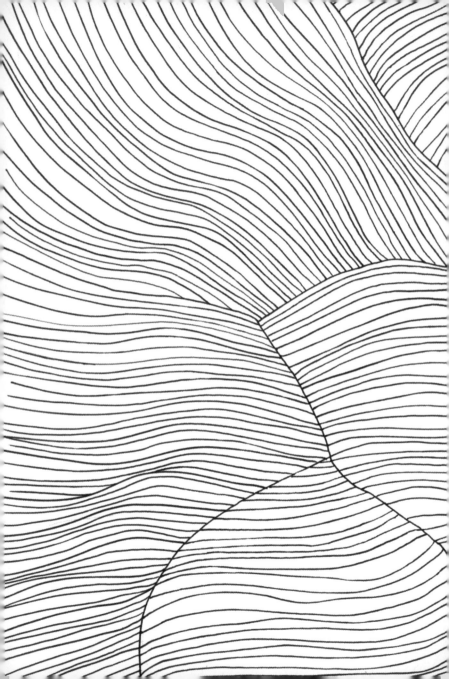

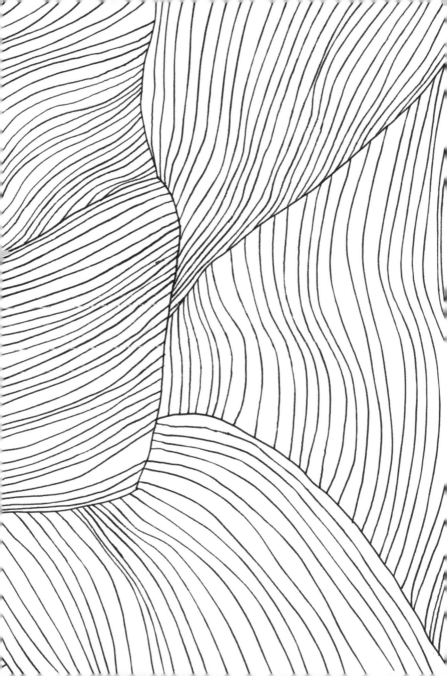

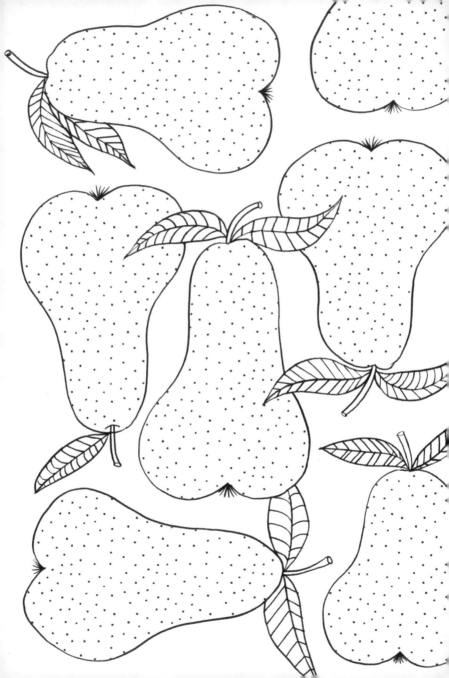

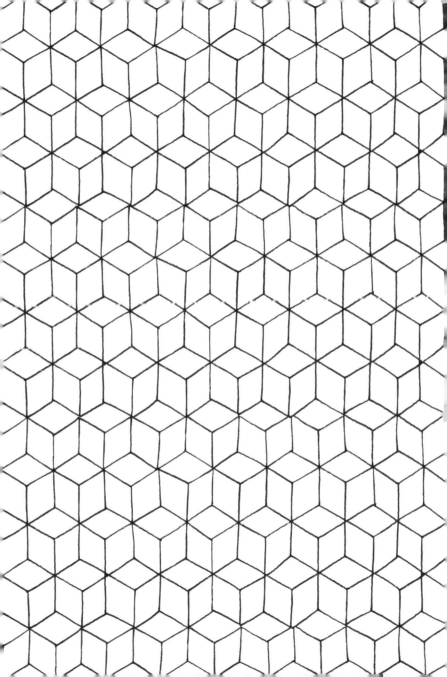

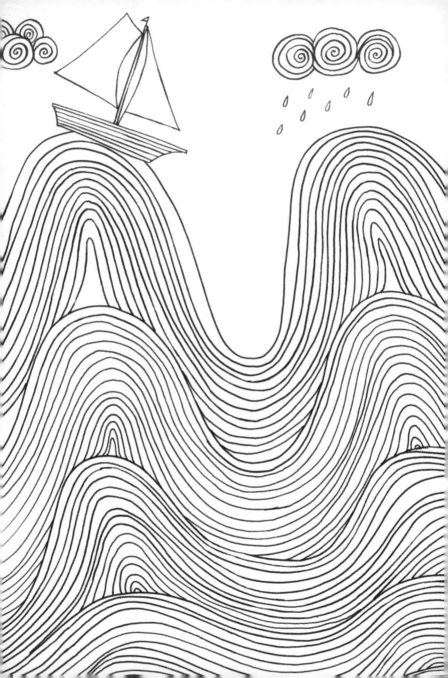

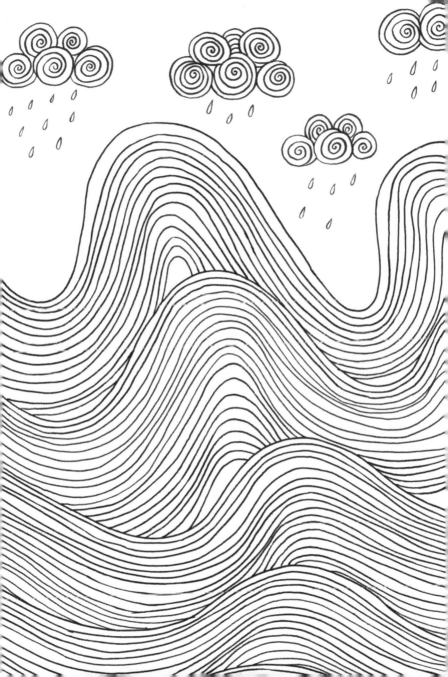

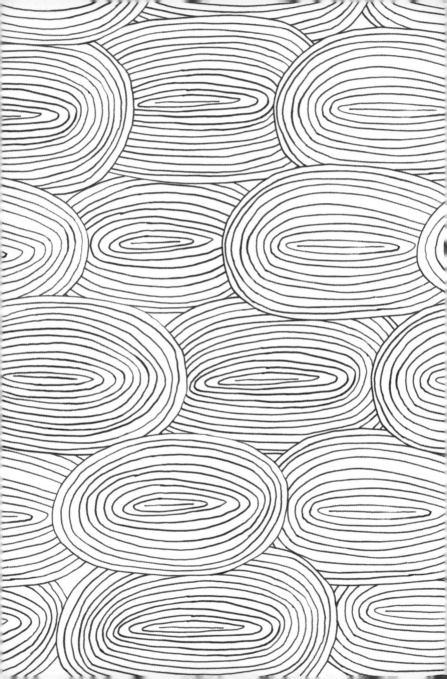

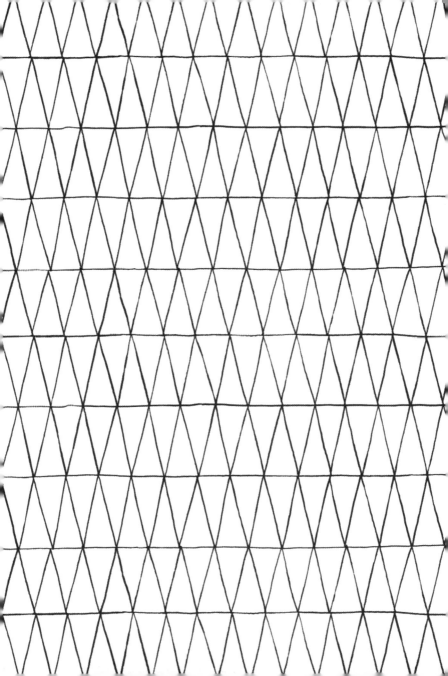

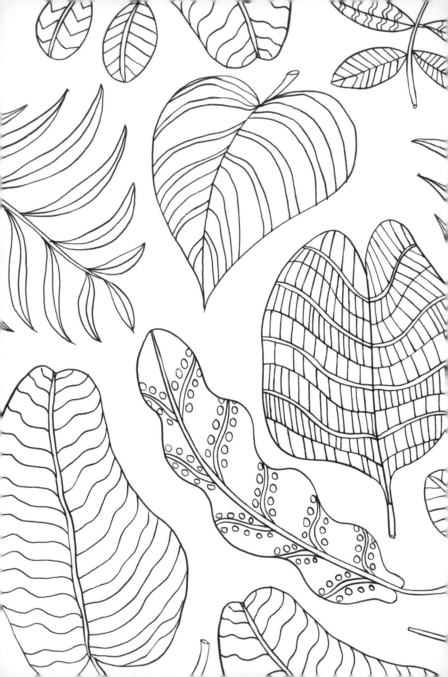

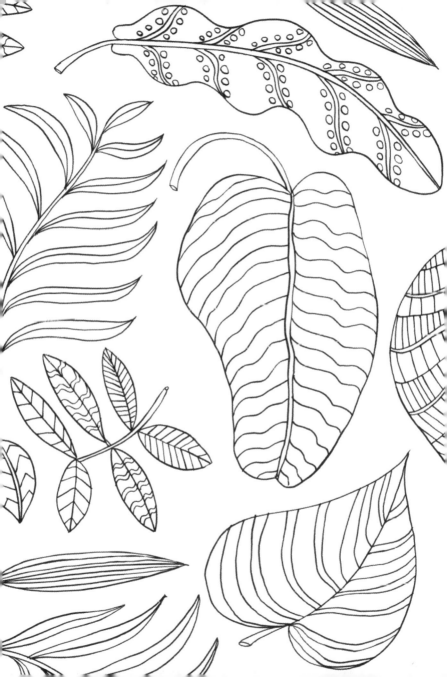

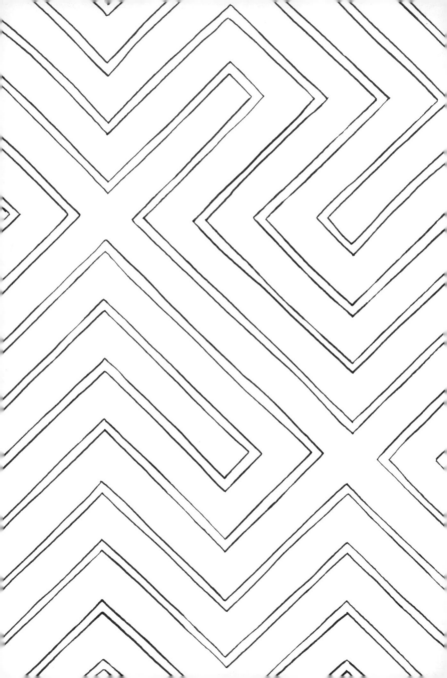

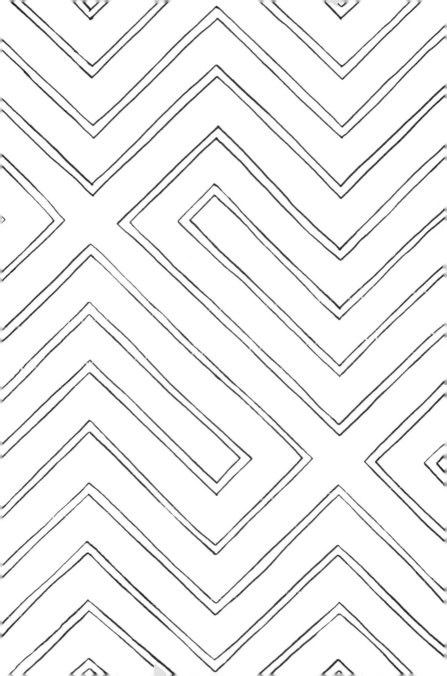

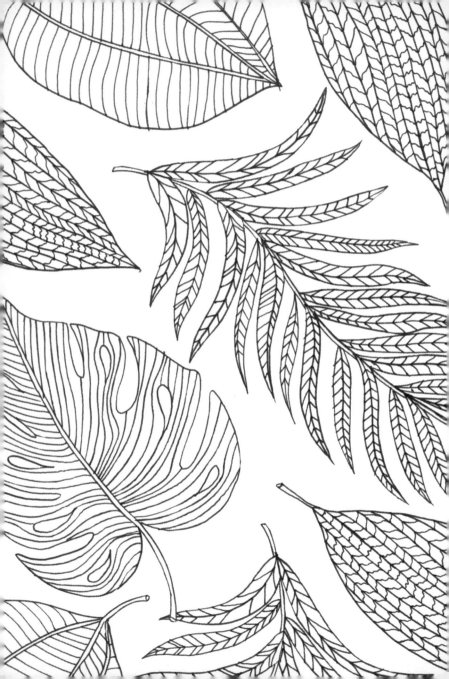

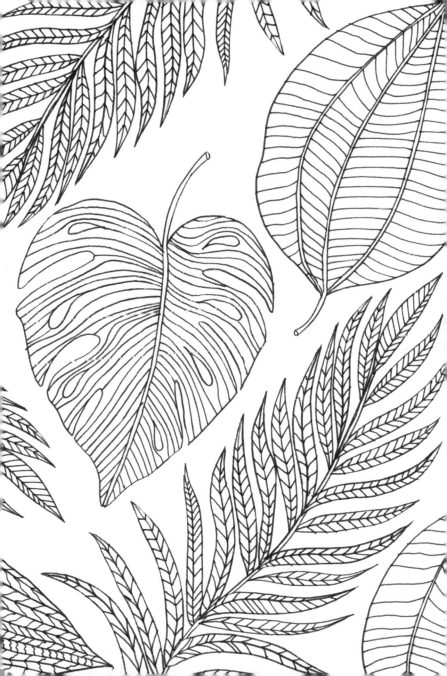

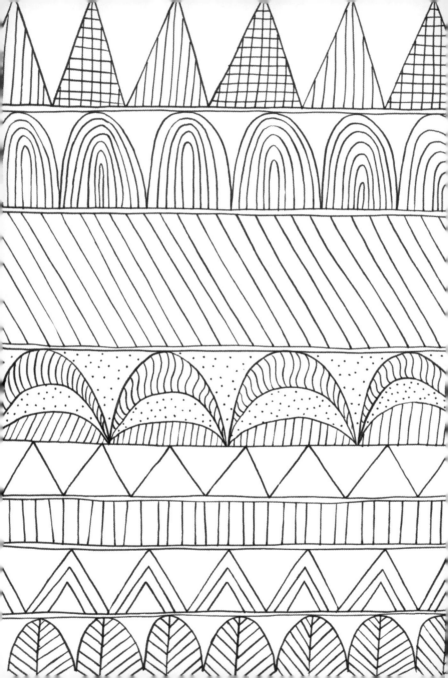

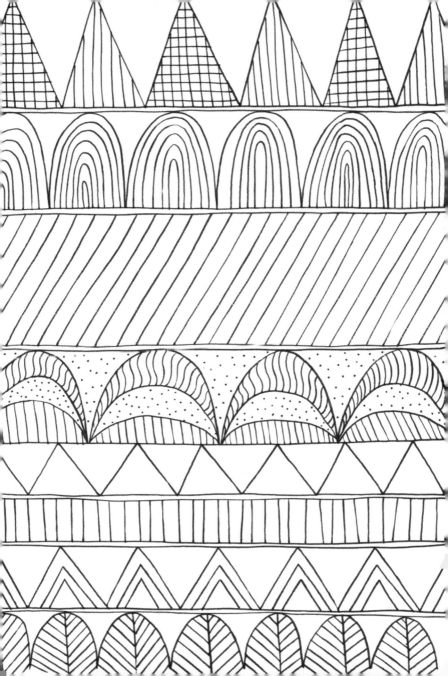

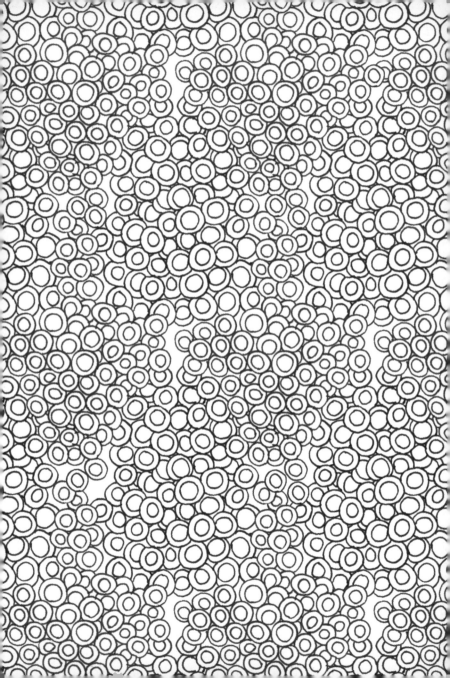

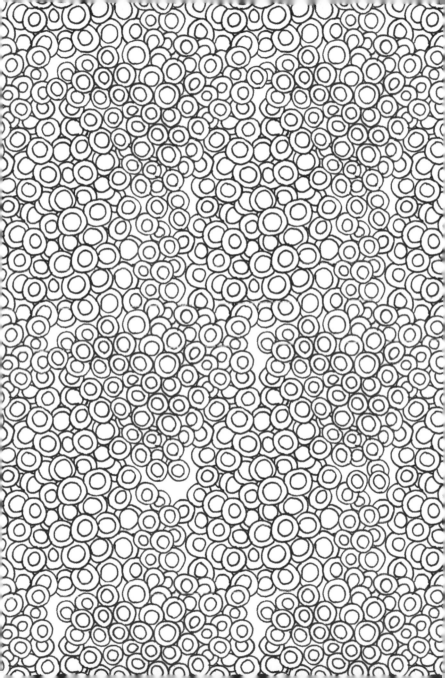

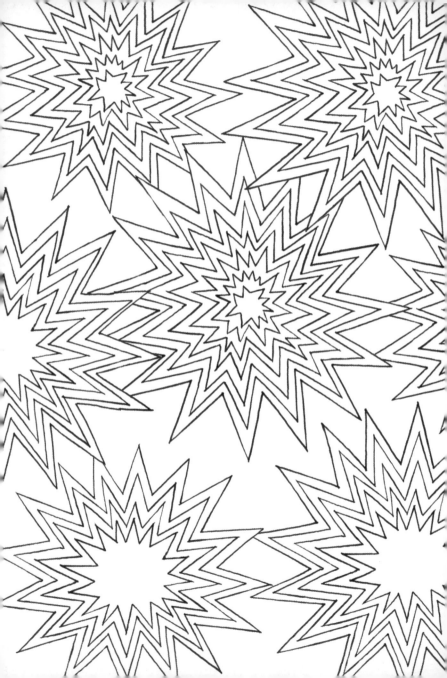

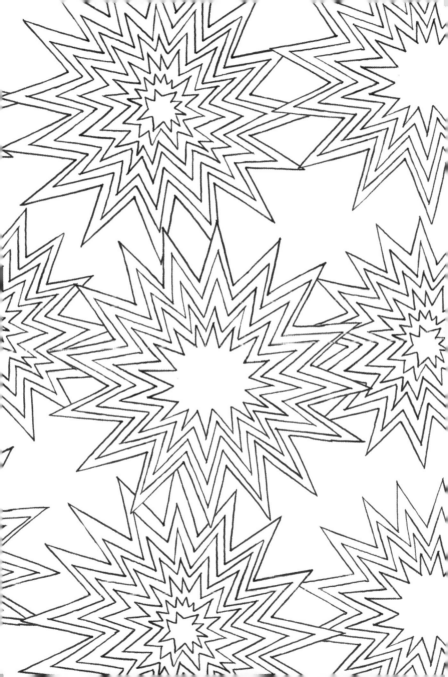

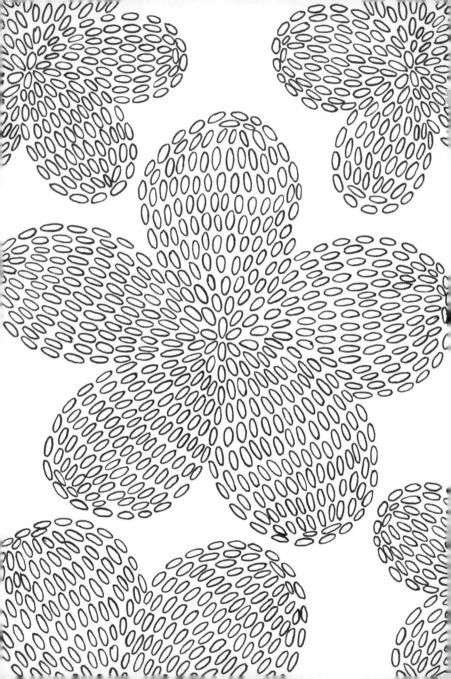

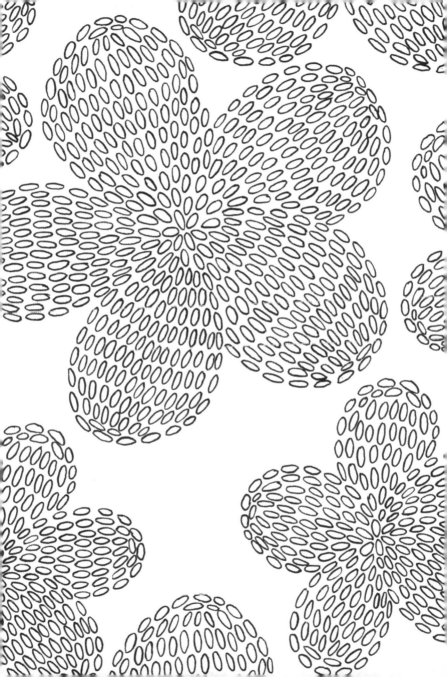

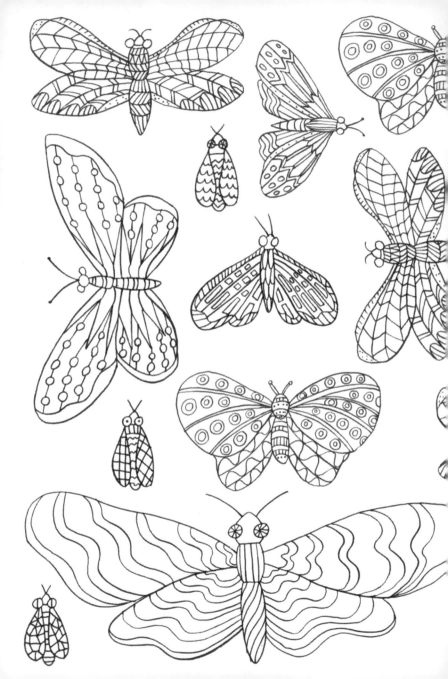

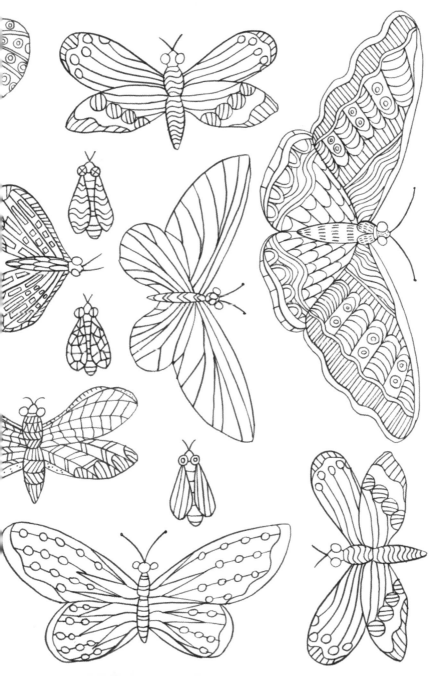

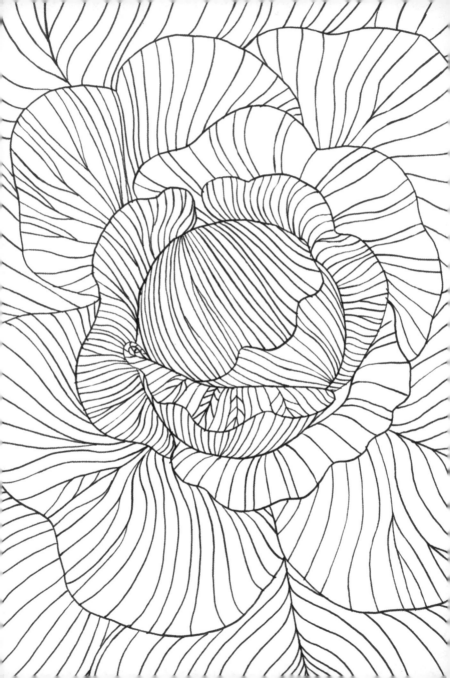

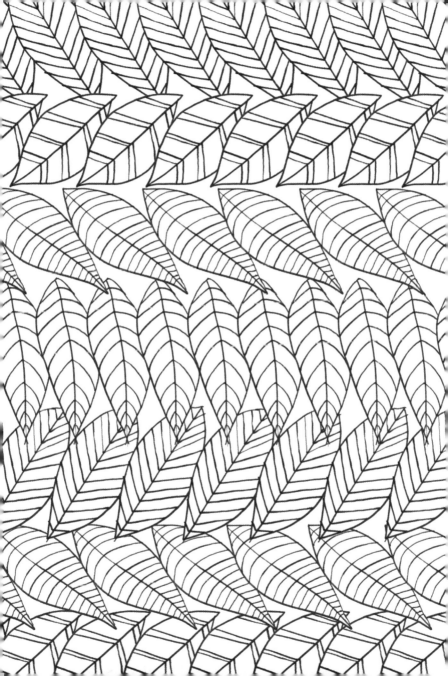

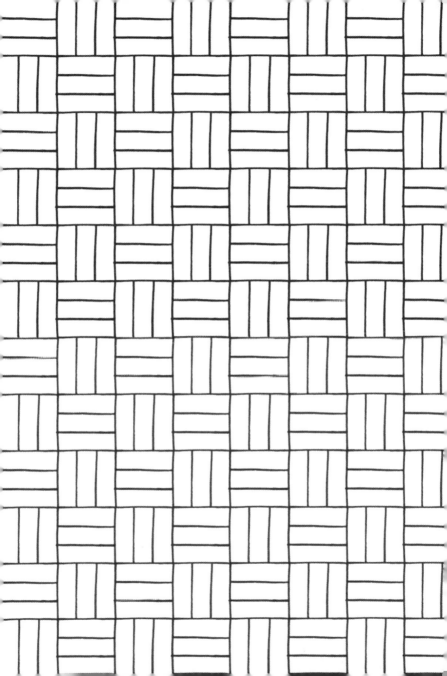

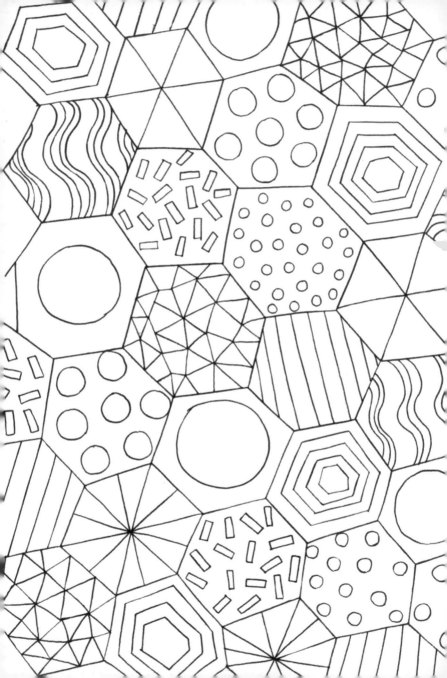

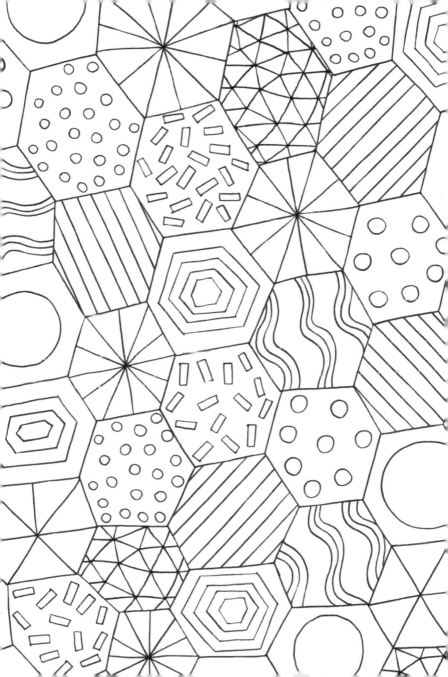

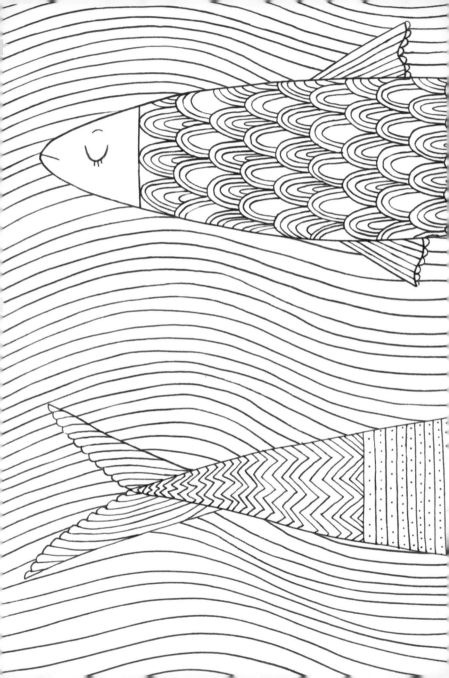

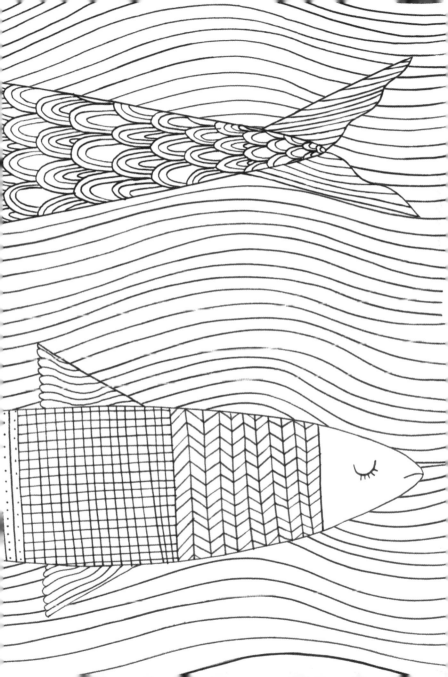

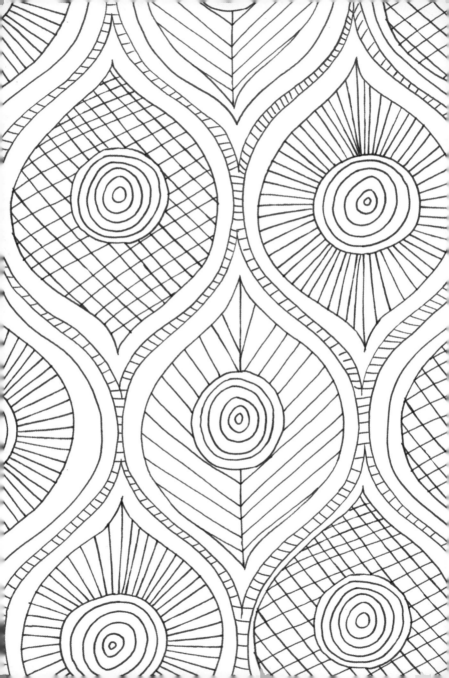

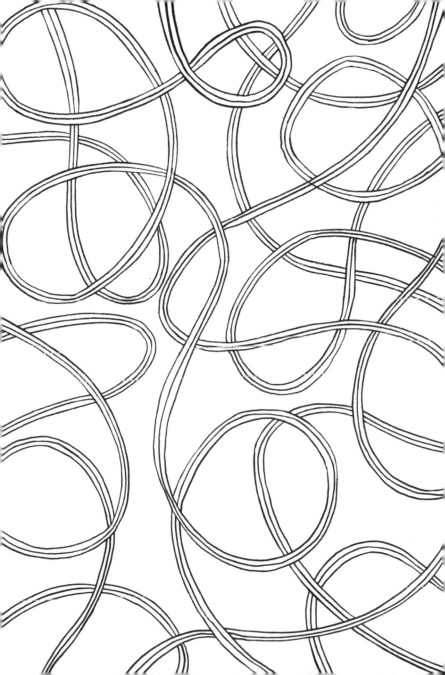

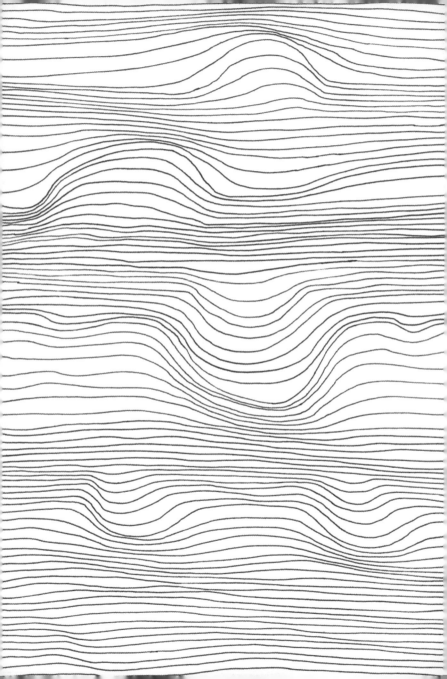

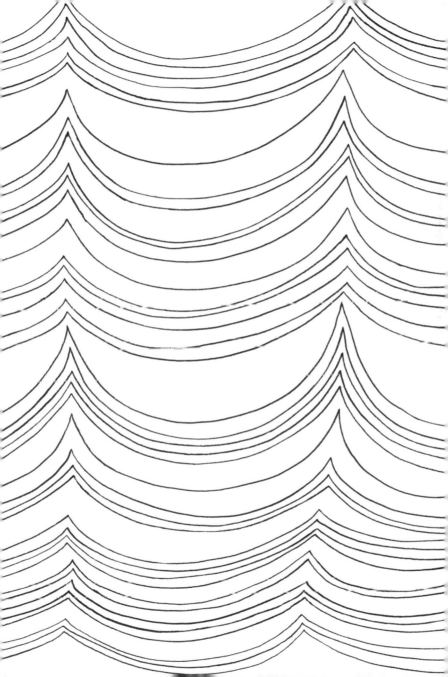

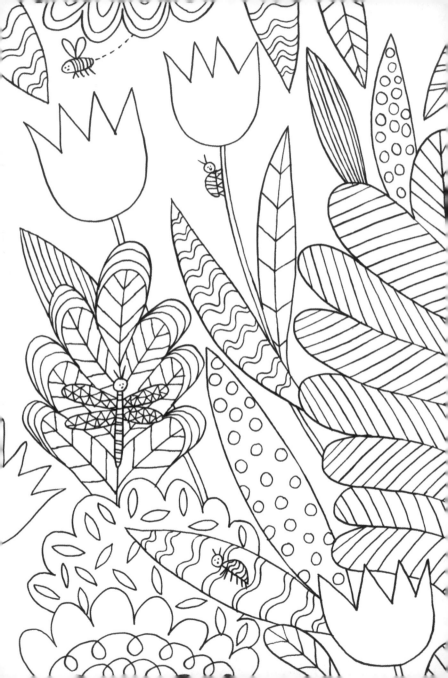

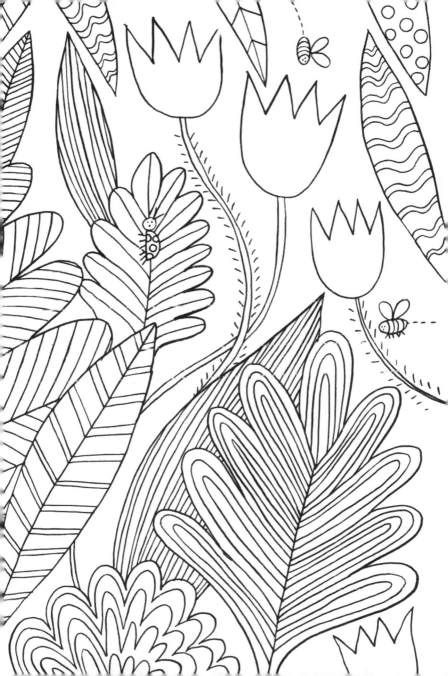

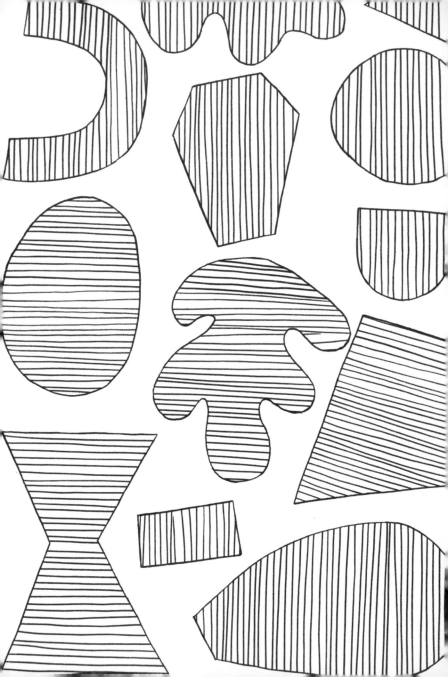

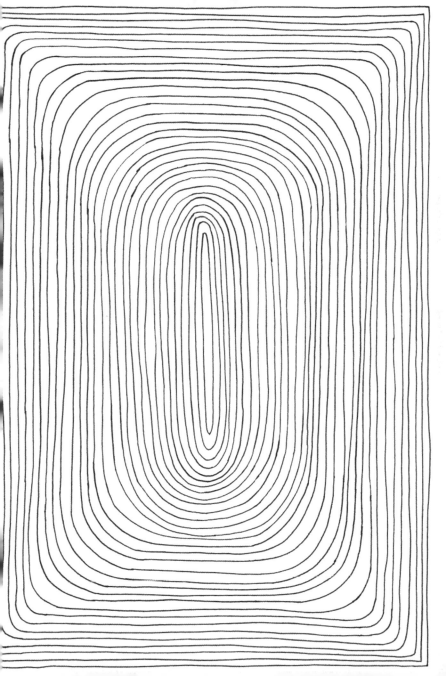

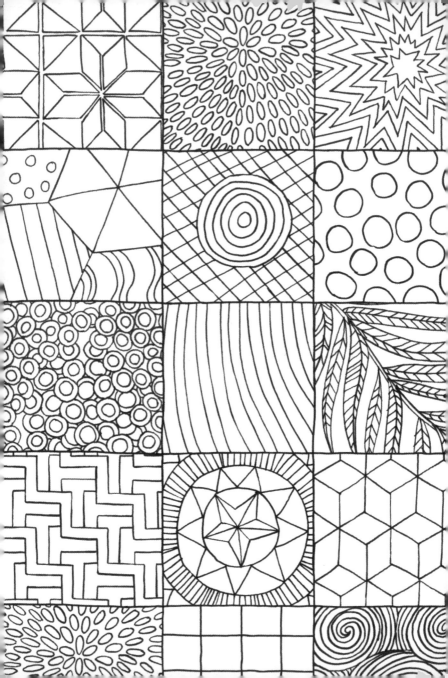

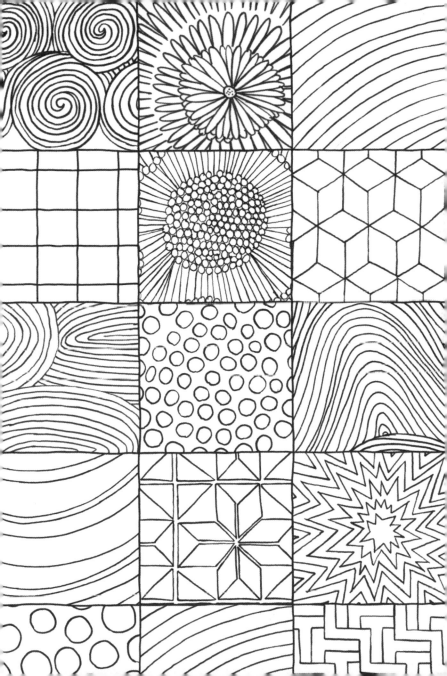

THANKS

I would like to thank my parents for taking me to a painting atelier every Wednesday afternoon. A special thank you to Cindy Chan – my cabbage pattern is dedicated to you.

EMMA FARRARONS
illustration & art direction

www.emmafarrarons.com